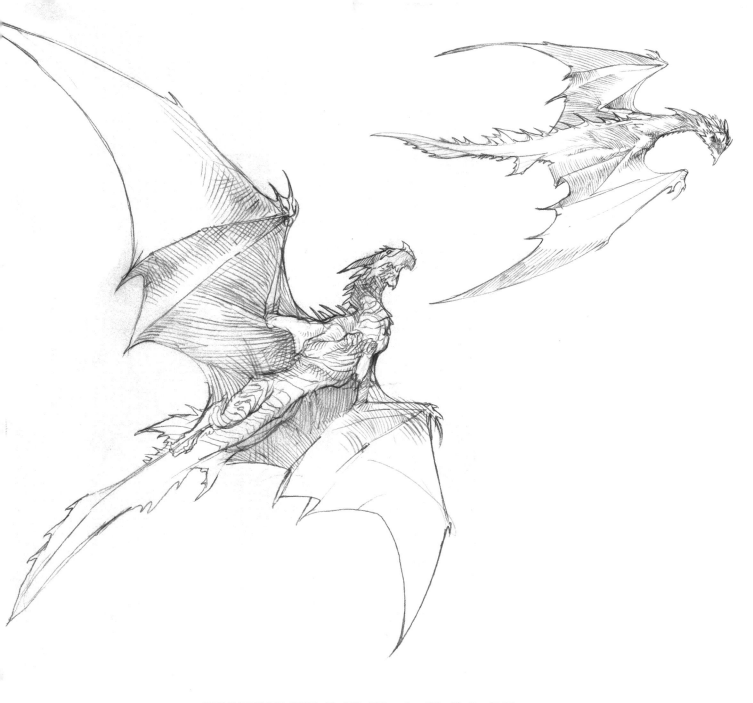

# SKETCH DRAGONS
## A Draw-Inside Step-by-Step Sketchbook

CINCINNATI, OHIO
www.impact-books.com

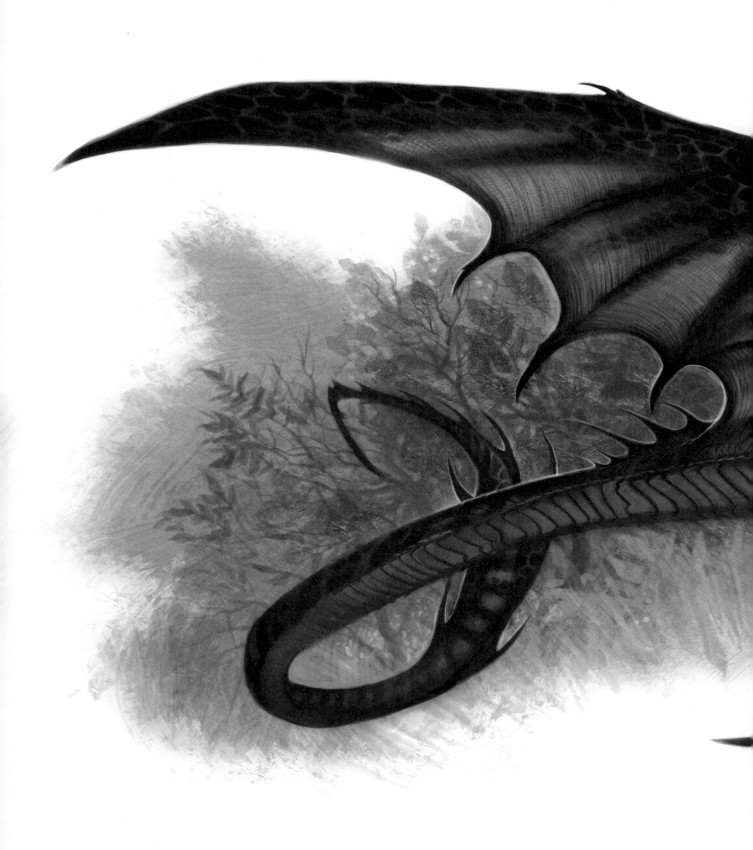

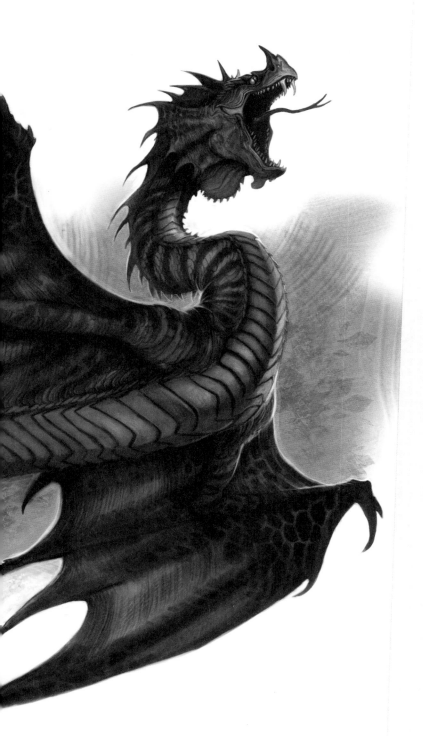

# CONTENTS

*Tips, advice and how-to instruction on:*

# THE "WHAT IF" FACTOR

All kinds of life are in the depths of your imagination. To access, all you have to do is ask yourself a "what if" question and then draw it. What if. . . a mountainside were so rich with nutrients that the viney trees that grew within it pushed the mountain higher and higher as its roots expanded? What if. . . while exploring high in the mountains in your airship, you found an oasis warmed and fueled by geothermal energy? What if. . . trees were so large they had their own ecology and were teeming with gigantic life-forms like arboreal elephants?

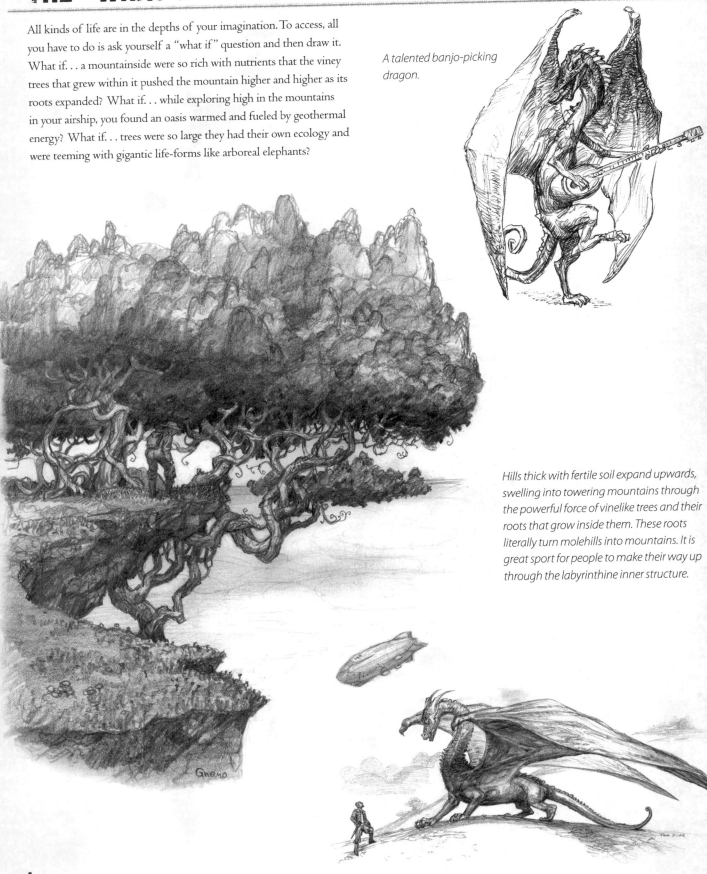

*A talented banjo-picking dragon.*

*Hills thick with fertile soil expand upwards, swelling into towering mountains through the powerful force of vinelike trees and their roots that grow inside them. These roots literally turn molehills into mountains. It is great sport for people to make their way up through the labyrinthine inner structure.*

# YOUR VOYAGE

Understanding principles is the better way to make art than to follow a particular formula for creating art. You don't need to follow the examples in this book like recipes. You can't make art that way. It has to be made from your own observations and a structure that is based on nature. Art is liberating. With this book you have the freedom to reinterpret the world around you. Use it to release yourself from the shackles of the ordinary and build your own new worlds. Have an extraordinary journey.

*"Art is not a transcript or a copy. Art is the expression of those beauties and emotions that stir the human soul."*
—Howard Pyle

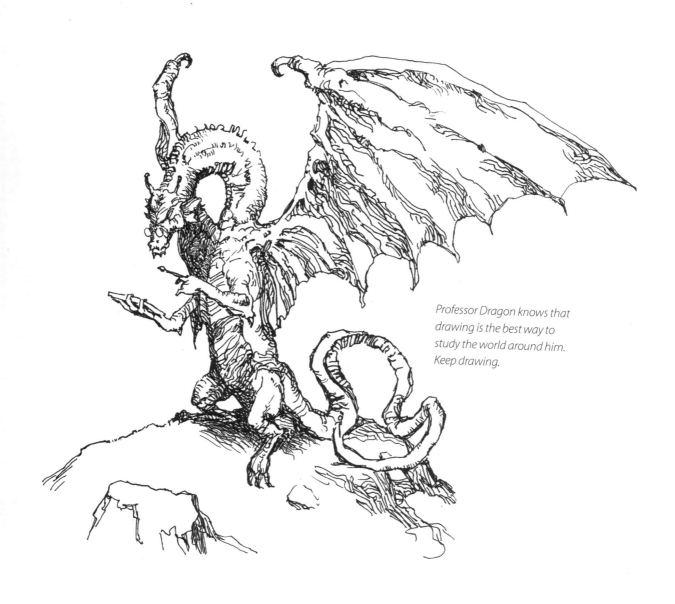

*Professor Dragon knows that drawing is the best way to study the world around him. Keep drawing.*

# DRAWING MATERIALS

The most important tools are no more than a simple notebook and pen or pencil. With these you can perform anatomy studies of dragons as well as begin drawing your own designs using a pencil.

## Selecting a Pencil

Pencil leads come in different degrees of hardness. Select pencil leads with an H designation if you want a hard lead. Select pencil leads with a B designation if you want a soft lead. The nice thing about an HB lead is that it's right in the middle—it's neither too hard nor too soft—and will be visible through transparent color, such as water-color, or easily covered with opaque colors.

There are also a variety of pencil types. You can get mechanical pencils, which allow you to use a variety of lead thicknesses. You could also use a lead holder, which is similar to a mechanical pencil, but holds a thicker lead that can be sharpened to a fine point with sandpaper and a craft knife. Of course, there are also the traditional wooden pencils. These can also be sharpened with sandpaper and a craft knife for a very sharp point, or you can use a pencil sharpener.

**Practice Your Drawing Technique**

*When designing dragons of your own, you will need to spend a lot of time drawing. Whether you choose to work digitally or traditionally, the drawing is the most important stage because this is where you determine the dragon's overall look and design.*

## Using an Eraser

Erasers are additional drawing tools. A white vinyl eraser doesn't mar the paper, despite repeated corrections. Eraser pens are readily available. The ends can be cut into points and used to create highlights.

## Selecting a Surface

In addition to this sketchbook, there are a variety of surfaces you can draw on. Bristol board is thicker than plain white or notebook paper. It easily accepts the pencil lead and allows for marks to be easily erased. Bristol board that is 14" × 22" (36cm × 56cm) and has a

## PENCIL LEADS

*The softer your pencil lead, the darker your mark and the easier it is to blend. If your lead is too soft, the pencil can easily smear, making your drawing look dirty. However, if the pencil lead is too hard, you will have to apply more pressure to the pencil to draw. This can mar your paper's surface. Work with a range of leads to achieve different effects, experimenting with different lead hardnesses to find one that works best for you.*

**Fill Your Sketchbooks with Ideas**
*The sketchbook is the place where your dragon ideas are born. Compile as many notes and ideas as you can. Try to work out the details of your designs before starting a finished drawing.*

vellum surface works nicely. Bristol board comes in pads, which are well suited for doing your final drawing before adding paint or scanning into the computer, as the sheets can easily be removed.

Sketchbooks are very important. The sketchbook is the artist's best tool. This is where all of your ideas and observations are jotted down, and the real creativity happens. Sketchbooks are also a good way to document and store your ideas. You never know when an old idea might spark a new concept. A simple doodle with notes might lead you to your best creation.

## Use Reference Material

Going to your library or bookstore and searching online will allow you to see the wide variety of dragons that other artists have created. In combination with natural history books, these can be a helpful inspiration for getting started.

## RESPECT COPYRIGHTS

*It's OK use other people's photos as a reference to get ideas, to see the pattern of a snake, for instance, but unless you have permission from the owner of that image, it is not acceptable to copy that image directly.*

**Drawing Supplies**
*Pencil on a smooth-surfaced large paper allows you to render high detail, and make changes fairly easily. The most important thing is to be patient. Take your time and don't rush.*

# PEN AND INK

Back a hundred or so years ago, pen and ink was the most common form of illustration seen in books or magazines. It was easy to reproduce and to print with little diminished quality from the original. Amazing works of art were created using a crow quill pen and a jar of black ink. Pen and ink is steeped in the metaphor and simile of line. You would do well to study this art. In addition to that, it's humbling to see what a practiced hand and mind can do with the simplest tools. So please seek out the masters and study them.

### Experiment with Marker Types
*Marker pens have a different line than a crow quill, a brush, a Rapidograph pen or a dragon tail. Anything you use to make your black lines will have its own properties. Experiment with all mediums and find something you like.*

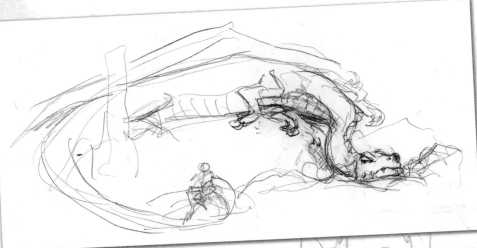

### Plan Out Your Ink Drawing with Pencil First
*Your ink lines can represent many things. They can be the outlines of your subjects, or they can represent tone and texture as well. These aspects can fight with each other so it's best to plan out your pen-and-inks. These two drawings are different versions of the same story: an artist, a particularly oblivious one, has mistaken the end of a dragon's tail for his pen quill. Draw your fantasy subjects based on what you can picture in your head. On the right, the neck and face of the dragon help tell the story of his interrupted sleep, so the second drawing explores a slightly different demeanor.*

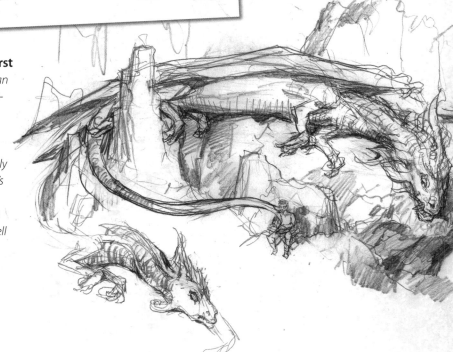

*Plan out your drawing here and on the following pages by sketching one or more different versions of your idea with pencil.*

# PEN AND INK

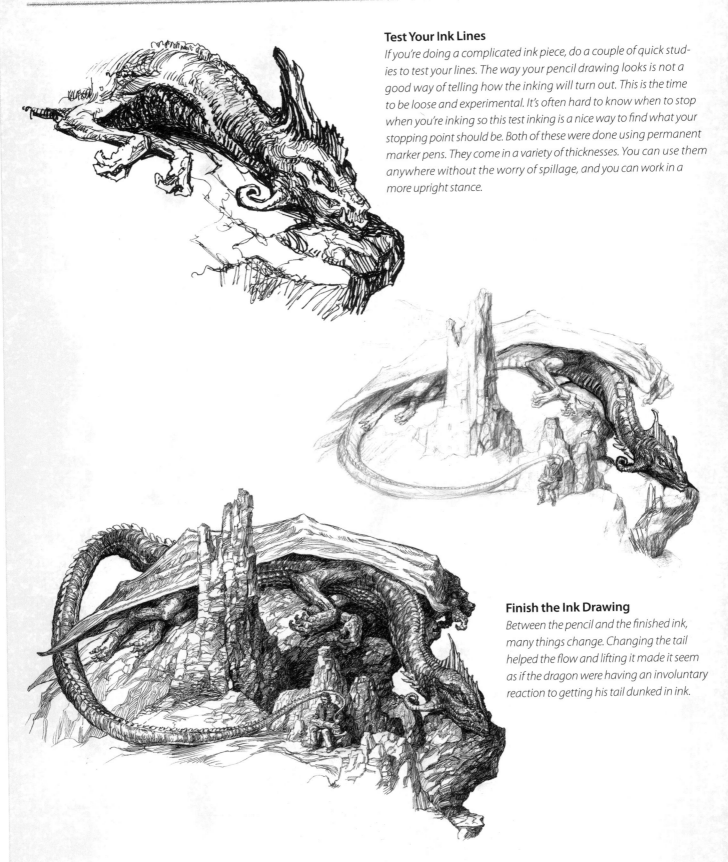

**Test Your Ink Lines**

*If you're doing a complicated ink piece, do a couple of quick studies to test your lines. The way your pencil drawing looks is not a good way of telling how the inking will turn out. This is the time to be loose and experimental. It's often hard to know when to stop when you're inking so this test inking is a nice way to find what your stopping point should be. Both of these were done using permanent marker pens. They come in a variety of thicknesses. You can use them anywhere without the worry of spillage, and you can work in a more upright stance.*

**Finish the Ink Drawing**

*Between the pencil and the finished ink, many things change. Changing the tail helped the flow and lifting it made it seem as if the dragon were having an involuntary reaction to getting his tail dunked in ink.*

*Experiment and test your ink lines here and on the following pages by sketching one or more of your ideas with different pens. Once you decide on something you like, you can do a finished version on a better surface, such as bristol board.*

# DRAGON ANATOMY

Hollow bones like those of a bird are common to all dragon species. This reduces their weight by thirty percent, aiding in flight.

It is believed that Leonardo da Vinci's extensive sketches of wing designs are based on those of the great dragon.

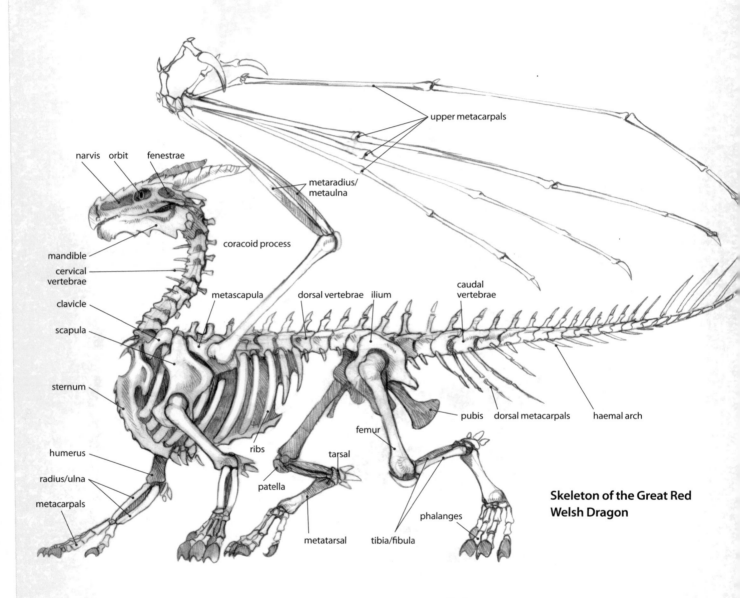

**Skeleton of the Great Red Welsh Dragon**

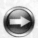 Learn more about dragons at http://ImpactSketchbooks.Impact-Books.com

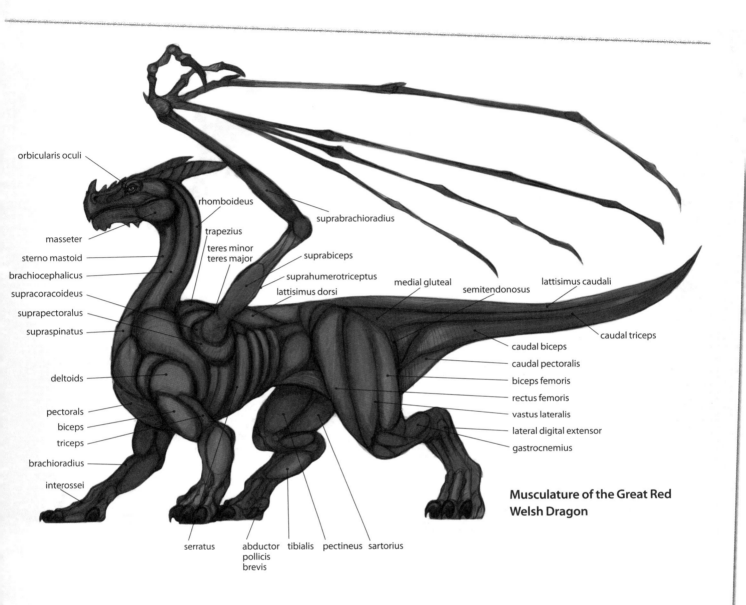

orbicularis oculi

masseter

sterno mastoid

brachiocephalicus

supracoracoideus

suprapectoralus

supraspinatus

deltoids

pectorals

biceps

triceps

brachioradius

interossei

rhomboideus

trapezius

teres minor
teres major

lattisimus dorsi

suprabrachioradius

suprabiceps

suprahumerotriceptus

medial gluteal

semitendonosus

lattisimus caudali

caudal triceps

caudal biceps

caudal pectoralis

biceps femoris

rectus femoris

vastus lateralis

lateral digital extensor

gastrocnemius

serratus

abductor
pollicis
brevis

tibialis

pectineus

sartorius

**Musculature of the Great Red
Welsh Dragon**

# DRAGON ANATOMY

Thoroughly understanding animal musculature and movement is important if you expect to use any type of creature often in your paintings. Building a visual catalog of animal imagery is a good place to start.

*Study animal anatomy books to provide a factual jumping-off point to imagination.*

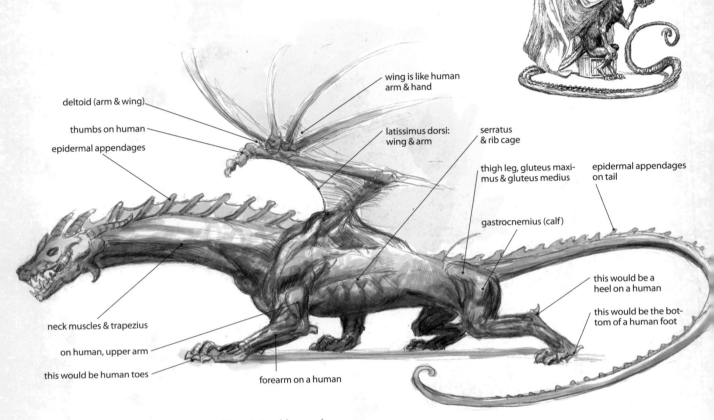

deltoid (arm & wing)

thumbs on human

epidermal appendages

wing is like human arm & hand

latissimus dorsi: wing & arm

serratus & rib cage

thigh leg, gluteus maximus & gluteus medius

epidermal appendages on tail

gastrocnemius (calf)

this would be a heel on a human

this would be the bottom of a human foot

neck muscles & trapezius

on human, upper arm

this would be human toes

forearm on a human

*Making up creatures takes high-powered imagining. Mammals, reptiles and birds are all four limbed. This dragon has four legs that it runs on plus two additional arms used as wings.*

## Think in 3-D

*Simplify forms to understand how it works in the third or fourth dimension. Here, motion is implied by the alert position of the dragon. The tail should look as if it's flicking back and forth like an agitated kitty cat. Much of inventing life is associating one creature in your mind with another. You really wouldn't go to a cat to use as reference for this animal, but the memory of how a cat moves can be a great influence in the gesture of the invented dragon.*

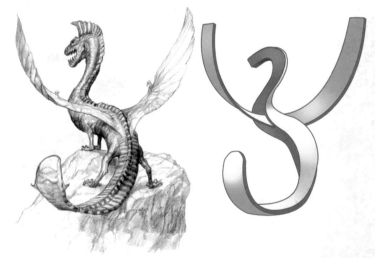

*Try simplifying the forms of one or more of your ideas here and on the following pages.*

# DRAGON ANATOMY

This dragon also has four arms; its extra set of arms form the wings.
This means that all the bones and muscles of these parts and their
connecting pieces will be duplicated.

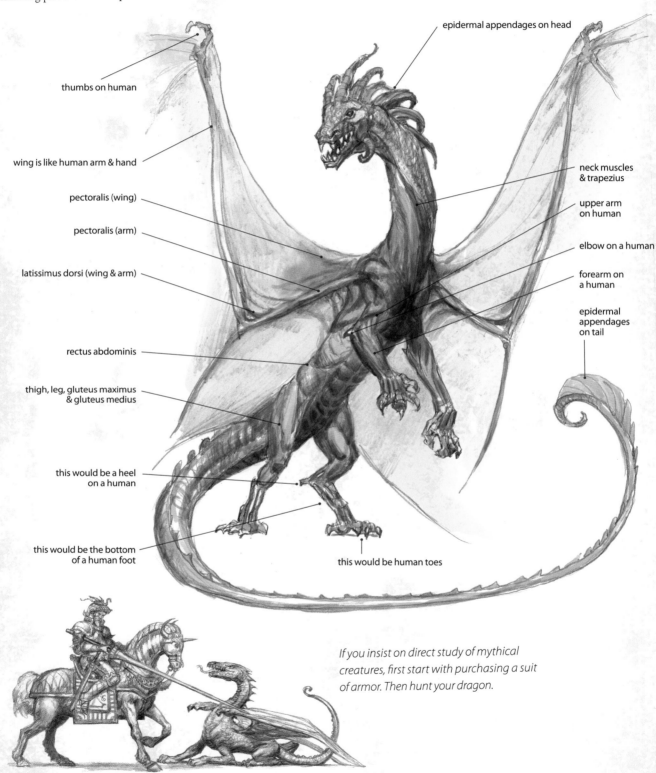

thumbs on human

epidermal appendages on head

wing is like human arm & hand

neck muscles & trapezius

pectoralis (wing)

upper arm on human

pectoralis (arm)

elbow on a human

latissimus dorsi (wing & arm)

forearm on a human

epidermal appendages on tail

rectus abdominis

thigh, leg, gluteus maximus & gluteus medius

this would be a heel on a human

this would be the bottom of a human foot

this would be human toes

*If you insist on direct study of mythical creatures, first start with purchasing a suit of armor. Then hunt your dragon.*

*Try your own version of one of the dragons shown at left here and on the following pages.*

# DRAWING DRAGON HEADS

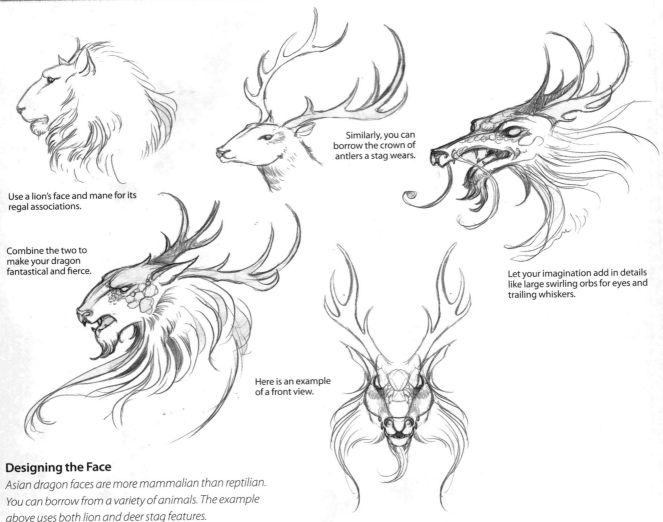

Use a lion's face and mane for its regal associations.

Similarly, you can borrow the crown of antlers a stag wears.

Combine the two to make your dragon fantastical and fierce.

Let your imagination add in details like large swirling orbs for eyes and trailing whiskers.

Here is an example of a front view.

## Designing the Face

*Asian dragon faces are more mammalian than reptilian. You can borrow from a variety of animals. The example above uses both lion and deer stag features.*

## THE DRAGON'S PEARL

*One day, a young boy was out looking for food. He came across a beautiful giant pearl nestled in the rice fields. He took it home with him and showed it to his mother. Afraid that the other villagers would be jealous, she quickly hid it inside a near-empty rice jar.*

*The next day as the mother prepared to make food, she opened the rice jar and, to her astonishment, the jar was brimming with rice. The pearl gleamed among the white grains. "It is a miraculous pearl!" she exclaimed in wonder. Joyously, mother and son shared the rice among their neighbors, careful to keep the source of their plenty a secret.*

*But eventually the secret came out and the villagers became wild with jealousy. They raided the house of the boy and his mother, determined to possess the magical pearl, and in the confusion and violence, the boy swallowed it. He was transformed into a beautiful dragon, and he danced away into the heavens with the flaming pearl.*

*Try sketching different versions of dragon heads.*

# DRAWING SERPENTINE DRAGONS

## Drawing the Body

*When drawing the body, use the sinuous form of a snake as your starting point.*

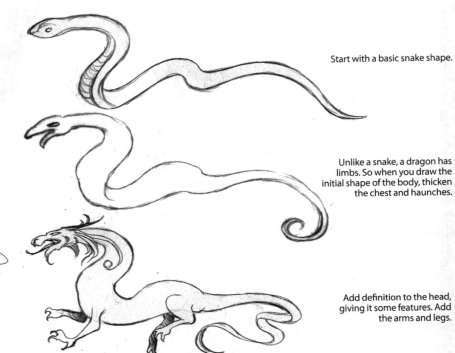

Start with a basic snake shape.

Unlike a snake, a dragon has limbs. So when you draw the initial shape of the body, thicken the chest and haunches.

Add definition to the head, giving it some features. Add the arms and legs.

## Define the Legs

*If you are having difficulty with arranging the dragon's limbs, think of a familiar quadruped like a dog. The dragon's bone structure is similar, though placement of the limbs (as well as the length of the limbs) will differ.*

Finish off the details (like scales) according to your personal preferences. You can extend the mane down the spine, like a horse's mane. Or even turn these into fiery or watery tendrils, curling out from the body. You can also add more volume to the tail.

Try to keep the knuckles aligned. Generally, a curved line can act as a guide for the structure.

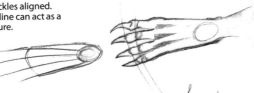

To create the basic shape, work from the ball of the foot, the pad of the sole area, and the claw tendons.

Note the similarities to a human foot, with forward weight and pressure placed on the toes.

## Depicting Claws

*When thinking about the claws, it's easier to break down the whole into its underlying structure.*

Here is a view of a relaxed foot.

Here the foot is tensed aggressively and with claws bared.

Flat pads on each toe indicate that weight is on this foot. Prominent tendons also indicate tension.

*Try sketching your dragon's body, and various body parts.*

# AMERICAN BANYAN WYRM

The wyrm has been depicted in many cultures throughout history. In order to capture the essence of this animal, there are certain qualities that are necessary to include. It's important to try to incorporate all of these qualities into one image:

- Solitary habits
- Inhabits swampy marshes around trees
- Coils in complex circles
- Swallows its prey whole

Exploring different kinds of scales found on snakes and lizards will help you come up with a unique yet believable pattern. Look at reference materials for banyan trees and their leaves to get the environment accurate.

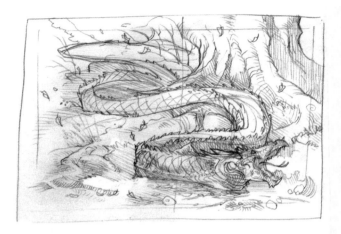

## WORKING OUT THE KINKS

*The coiling shape of the wyrm can get confusing, so establish the structural framework with basic shapes. The form of the wyrm acts like a stretched-out Slinky.® Here you can see the angle of the internal structure and the arrows that indicate the direction all the scales need to follow.*

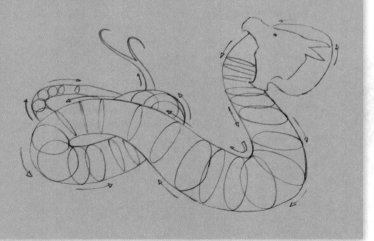

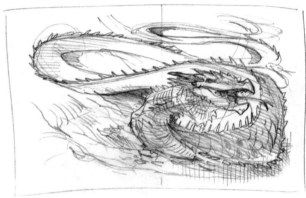

### Thumbnail Design Sketches

*Beginning with compositional design sketches, experiment with several ideas for the wyrm's position and placement. These early design drawings don't demonstrate the coiling power of the wyrm to the best effect. A position where the creature is rearing up and creating loops produces more drama and looks more like the infinity symbol.*

 Learn more about dragons at http://ImpactSketchbooks.Impact-Books.com

*Experiment with thumbnail sketches. Don't worry about getting these perfect—the idea is to try different things.*

# AMERICAN BANYAN WYRM

**Do the Final Drawing**

Draw the composition with an HB pencil, referring to your thumbnail sketches. As you work, keep in mind the wyrm's anatomy and its directional flow. The scale pattern you use is completely up to you; here are thick, pointed, armored scales like those on a rattlesnake.

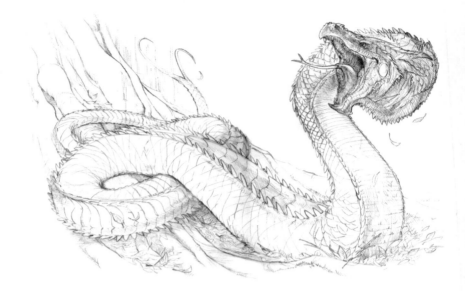

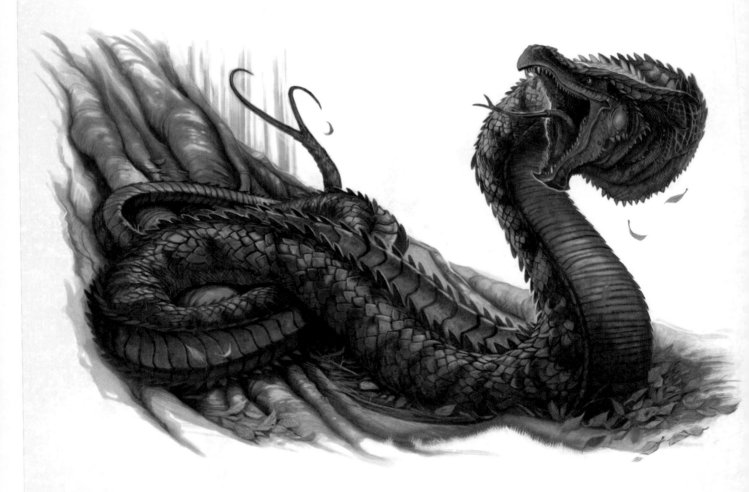

*When you've decided on a thumbnail sketch you like, do a slightly more finished sketch here, then do an even more finished version on a better surface, such as bristol board.*

# DRAWING REPTILIAN DRAGONS

In contrast to Eastern dragons, which are more serpentine, Western dragons are more reptilian in appearance. Often cloaked on either side by giant batlike wings, the Western dragon has a large and looming presence as he soars across the sky. While Eastern dragons are generally portrayed as benevolent creatures, Western dragons are often thought of as fierce beasts and worthy foes of knights-errant.

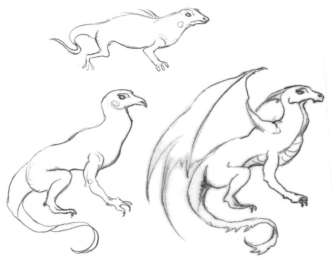

### Drawing the Body

*Use the basic shape of an iguana as a starting place for inspiration. Then, start creatively exaggerating and emphasizing features. For example, elongate the neck, limbs and tail. Draw larger claws for a more aggressive attitude. To accommodate the larger limbs, expand the chest cavity. Slowly fill in more of the details, like wings and distinctive facial features.*

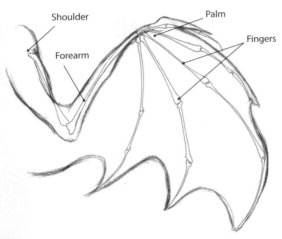

### The Anatomy of the Wing

*Dragons are often depicted with leathery, batlike wings. Understanding the underlying structure of a wing will help you build a stronger composition. Simply think of a wing as a human arm, with the spines becoming elongated fingers connected by webbing.*

### Flight vs. Rest

*Wings fully unfurl in flight to let the dragon glide. When resting, the wings fold up like a pleated fan.*

## SAINT GEORGE AND THE DRAGON

*A very well known evil dragon that has inspired paintings for centuries is the dragon slain by Saint George. This dragon once terrorized a small town, nesting at its spring. Unable to drink from their water source, the frightened citizens were forced to appease the terrible creature by drawing lots to see who would be sacrificed.*

*One day, the princess drew the lot that marked her as the sacrifice. Saint George came passing through on his travels, and upon hearing this dire tale, rode out to do battle with the beast. In the ensuing fight, he slew the dragon and rescued the maiden.*

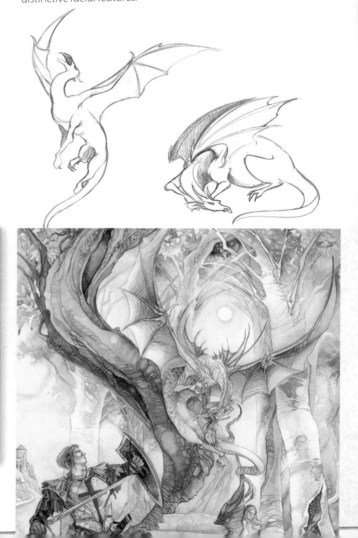

*Choose a reptilian animal to model a sketch of your dragon's basic shape, making alterations, such as adding wings or a longer tail, as you like.*

# DRAWING REPTILIAN DRAGONS

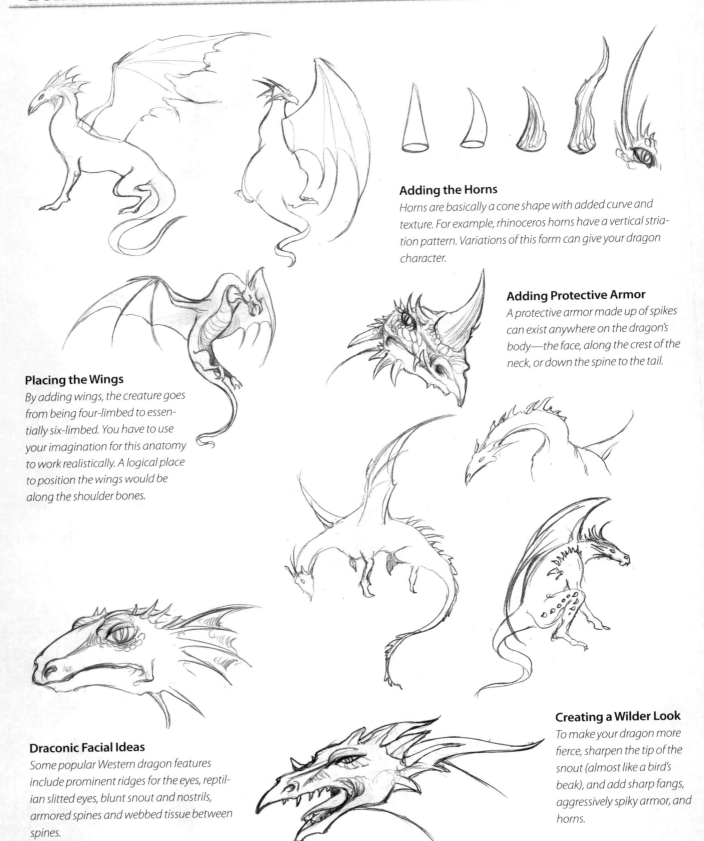

## Adding the Horns

Horns are basically a cone shape with added curve and texture. For example, rhinoceros horns have a vertical striation pattern. Variations of this form can give your dragon character.

## Placing the Wings

By adding wings, the creature goes from being four-limbed to essentially six-limbed. You have to use your imagination for this anatomy to work realistically. A logical place to position the wings would be along the shoulder bones.

## Adding Protective Armor

A protective armor made up of spikes can exist anywhere on the dragon's body—the face, along the crest of the neck, or down the spine to the tail.

## Draconic Facial Ideas

Some popular Western dragon features include prominent ridges for the eyes, reptilian slitted eyes, blunt snout and nostrils, armored spines and webbed tissue between spines.

## Creating a Wilder Look

To make your dragon more fierce, sharpen the tip of the snout (almost like a bird's beak), and add sharp fangs, aggressively spiky armor, and horns.

*Sketch some variations you might want to try for various body parts. Different combinations of horns, wings, armor and facial details can create your own unique results!*

# RENDERING SCALES

When drawing scales on a dragon, you can use several different techniques, depending on what part of the dragon's body you're tackling. Fish, lizards and sea turtles are all good examples of places to look for inspiration.

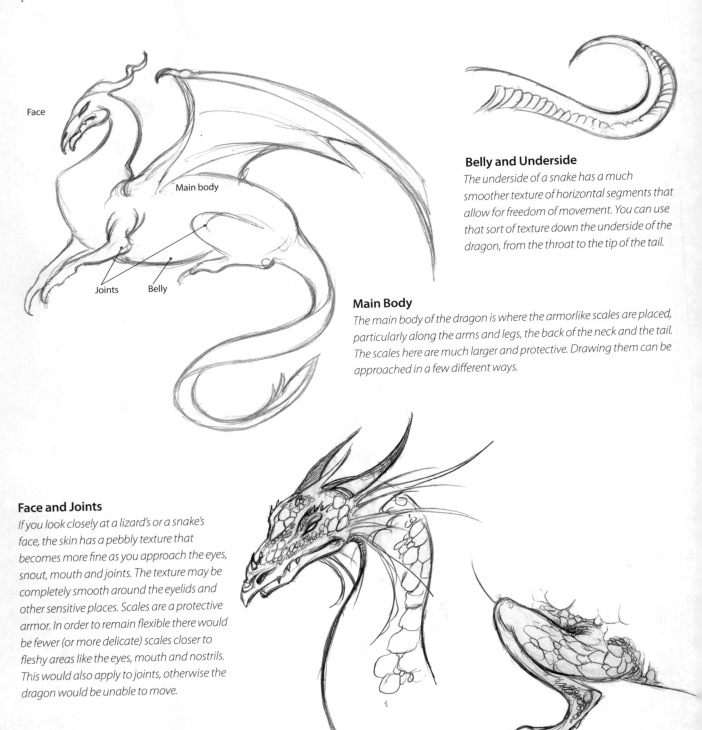

Face

Main body

Joints    Belly

## Belly and Underside
*The underside of a snake has a much smoother texture of horizontal segments that allow for freedom of movement. You can use that sort of texture down the underside of the dragon, from the throat to the tip of the tail.*

## Main Body
*The main body of the dragon is where the armorlike scales are placed, particularly along the arms and legs, the back of the neck and the tail. The scales here are much larger and protective. Drawing them can be approached in a few different ways.*

## Face and Joints
*If you look closely at a lizard's or a snake's face, the skin has a pebbly texture that becomes more fine as you approach the eyes, snout, mouth and joints. The texture may be completely smooth around the eyelids and other sensitive places. Scales are a protective armor. In order to remain flexible there would be fewer (or more delicate) scales closer to fleshy areas like the eyes, mouth and nostrils. This would also apply to joints, otherwise the dragon would be unable to move.*

*How do you want your dragon's scales to look? Where will you place them? Try some ideas here.*

# RENDERING SCALES

## Fish Scales

Fish-type scales have crescent overlapping shapes. They don't all have to be the same size, or completely even. In fact, you want some variety in size or else it will look unnatural. Create larger plates across the back and hindquarters. As you get toward the tip of the tail, let the scales get smaller. To get a more draconic, armored look, put some randomized jagged edges on the plated scales.

## Consistency Is the Key

Keep the scales going in a consistent direction along the dragon's body, aligning with the limbs. They should move down the neck toward each limb and toward the top of the tail. Remember, you don't have to draw every single scale.

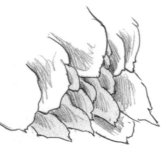

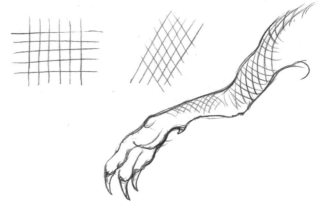

## Lizard Skin Scales

For a smoother type of scale, you can use a crosshatching pattern. This is basically a grid of lines. It is skewed at an angle to create diamond shapes, then rounded to cling to the three-dimensional form of the dragon's muscles.

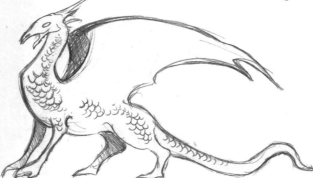

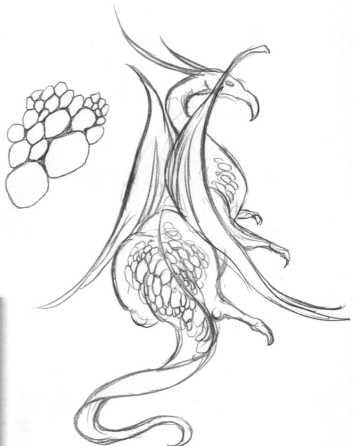

## SEEING BEYOND STEREOTYPES

While most Eastern dragons are representations of benevolence, and most Western dragons are incarnations of evil, there are exceptions to both types: malevolent Asian spirits and benign European dragons.

What's more, there are a myriad of dragons who fall outside of these simplistic descriptions. Quetzalcoatl of South America, with its serpentine body and feathered wings; Fafnir, a wingless reptilian creature slain by Siegfried; the nine-headed Hydra that Hercules was tasked to kill—all exist outside the commonly accepted stereotypes about dragons.

## Sea Turtle Scales

These are a more abstracted shape. Think of a cluster of rough circular or oval shapes of all sizes, squished up against one another.

*Try some of the types of scales shown here. Try to make your scales consistent!*

# DRAGON ARMOR

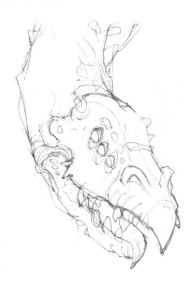

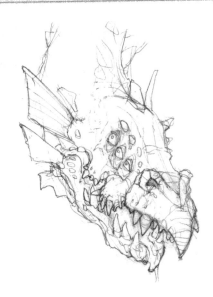

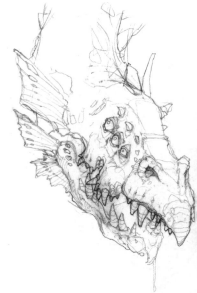

**1** *Sketch out the major shapes of the face, and plot a centerline through the head and neck. Use different elements of crocodile and Tyrannosaurus rex skull anatomies.*

**2** *Add the ears and start detailing the jaw lines with teeth. The skin should show a bit of the coarseness and major lines of the skull underneath.*

**3** *Add more detail to the ears, the teeth and the skin around the orbits of the multiple lids and eyes. Leave space in the gums for the larger teeth. This gives the impression that those jaws could fit right together when closed.*

## NATURAL WEAPONS

There's no good reason why you can't give dragons additional armor and weapons, but most of the time they're described as having what nature alone has given them. Their horns, plates and scales act as armor, and their fiery breath, claws and tail act as offensive weapons.

## DRAGON ARMOR: SKIN AND SCALES

There's a loose science to skin and scales. Snake and tree frog patterns hold the same sort of random, segmented shapes, and studying more about how skin and scales grow will help you sketch them.

## IT'S NEVER TOO LATE

Sometimes a sketch might need revisions late in the game; don't be afraid of changing it. In the last step this dragon lost an eye in order to gain some needed facial expression.

**4** *Finish your dragon with the crown of wrinkles and scales along the forehead following the centerline. Darken the outlines, erase the spot highlights, and your dragon is ready to take a bite out of its next meal.*

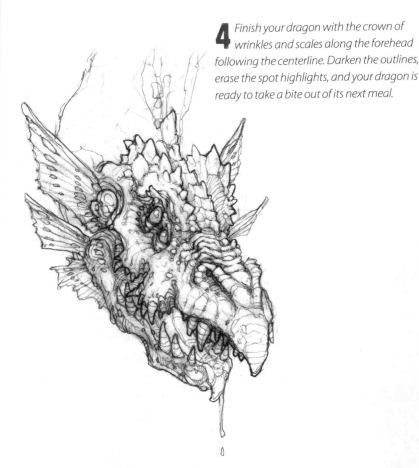

*What kind of skin and scales will your dragons have? Try looking at some real reptiles and amphibians for ideas.*

# DRAGON FIRE

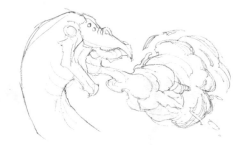

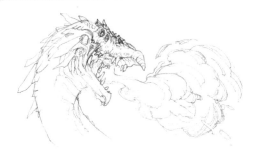

**1** *Begin with the basic shapes that form the neck and main features of the dragon, making a slight twist in the neck. Then play with the chaotic shapes that form the fire. This might take some erasing and resketching, but settle on something that looks believable.*

**2** *Add specifics to the dragon: teeth, scales, eyelids and ears. This jaw structure is a mix of crocodile and Tyrannosaurus rex anatomy. You can take a lot of information directly from a good reference. This is especially helpful for the folds in the neck and the muscles that connect the upper and lower palate. When you sketch larger scales, think of them as warts or hair—apply them randomly.*

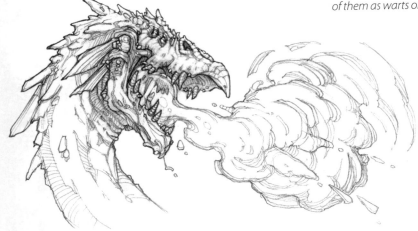

**3** *Tighten everything up. Outline the major shapes while adding shadows, and erase highlights to make the forms more three-dimensional. Remember to treat fire or magic as an additional light source that will create a whole new range of reflective light.*

## LISTEN CLOSELY: EAR ADVICE

*Notice the ears have bent down to close when our dragon fires off her breath. This is a reflex reaction that you'll see animals do to protect themselves. It's like closing your eyes when you sneeze.*

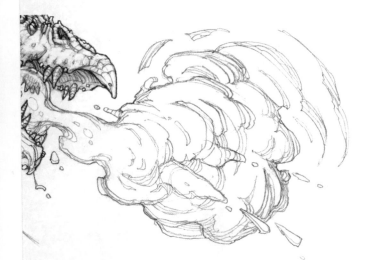

### Technique: Fire

It's the fantasy artist's job to capture real-life moments and assemble them into something that's impossible, but believable. Here are some tips for drawing realistic fire:

1 Think about what your breath looks like in cold weather. The vapor forms chaotic smokelike waves and eddies as it's blown outward.

2 Look at a campfire or the smoke from incense (or pictures of both). Watching how smoke moves and flows will help in creating believable dragon breath.

3 Look at photos of fire and explosions. You'll notice that the heat almost instantaneously starts to rise straight up. Create a chaotic stream of fire, keeping in mind the direction it's shooting and how the smoke will rise.

*Do some sketches of smoke, fire and explosions.*

# BRITISH SPITFIRE DRAGONETTE

The dragonette is a complex animal with many possible variations. You need to show these variations to best illustrate its uniqueness, such as:

• the ability of the dragonette to be ridden;
• the tack and harness needed;
• the gear worn by the dragonier.

Designing the dragonette's markings should begin in the concept stage. This one was inspired by raptors and warplanes, which are camouflaged against the ground from above and against the sky from below. The markings on the dragonette are very similar to those seen on World War I German airplanes.

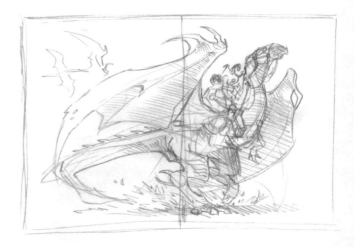

## Sketch the Composition

*Develop several thumbnail sketches in your sketchbook that include all the elements you want in the image.*

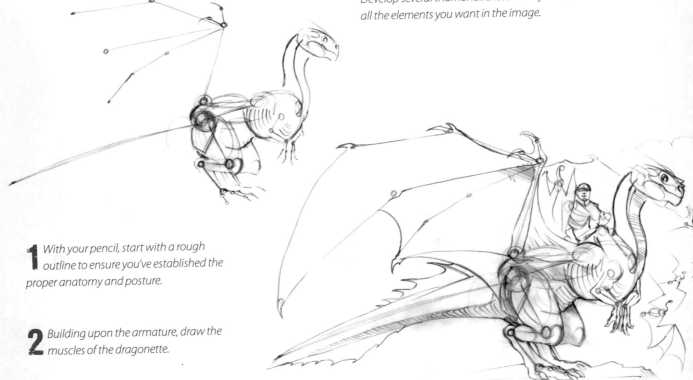

**1** *With your pencil, start with a rough outline to ensure you've established the proper anatomy and posture.*

**2** *Building upon the armature, draw the muscles of the dragonette.*

## ESTABLISHING PROPER ANATOMY AND POSTURE

*The human dragonier may make this drawing seem complicated. Reduce the possibility of confusion by creating an armature to establish each figure's basic structure and form. An armature is the foundation the drawing (or sculpture) will be built upon. In this case, the rough, skeletal outline of the dragonette serves as the armature for the drawing.*

*Do some thumbnail sketches that include all the elements you want in your final image.*

# BRITISH SPITFIRE DRAGONETTE

**Complete a Final Drawing**

*Do the final drawing with an HB pencil using your thumbnail sketches and armature drawings to guide you.*

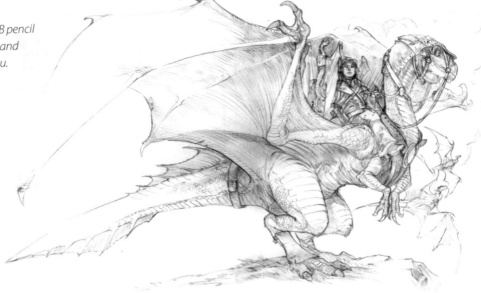

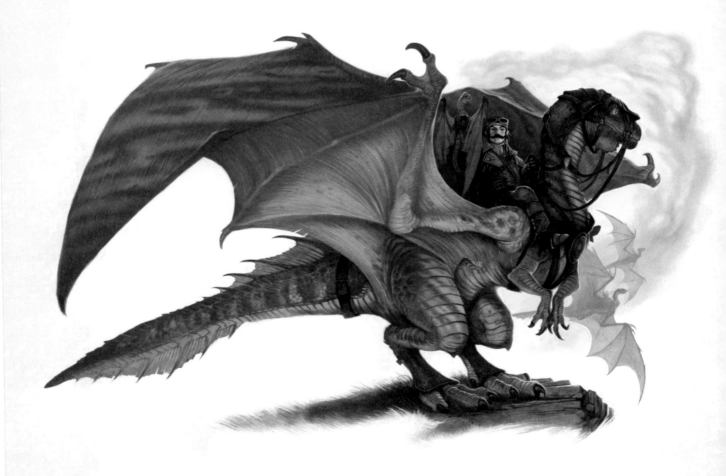

*If you need to continue sketching your ideas, do it here, then complete a final drawing on another sheet of paper, giving it some color if you like.*

# NORTH AMERICAN WYVERN

The North American wyvern's habitat is particular to the Rocky Mountains of the United States and its colorations are unique to its species. As with the other dragons, make a list of your wyvern's attributes that will be explored in your work before getting started:

- two-legged;
- alpine habitat;
- rugged build;
- spiked and clubbed tail.

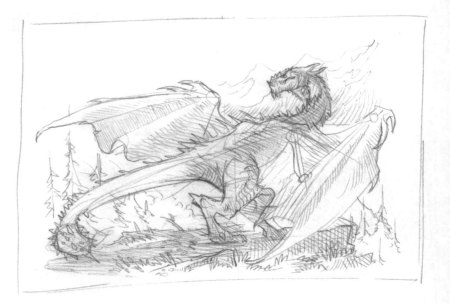

### Create a Thumbnail Sketch

*Work out the details by completing some thumbnail sketches. Since the wyvern's spiked tail is the most fascinating feature, place it in the foreground. The patterned wings, musculature and scales also should be showcased. Placing the animal against a backdrop of mountains illustrates its habitat.*

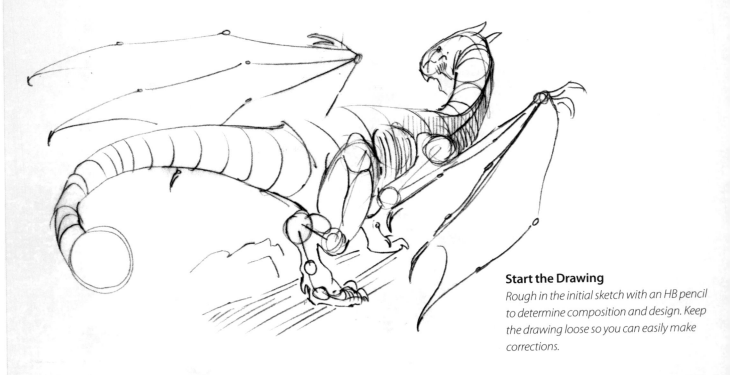

### Start the Drawing

*Rough in the initial sketch with an HB pencil to determine composition and design. Keep the drawing loose so you can easily make corrections.*

 Learn more about dragons at http://ImpactSketchbooks.Impact-Books.com

*Do some thumbnail sketches here.*

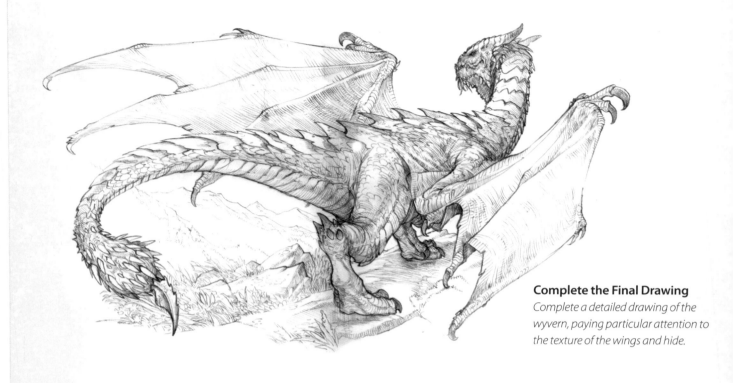

**Complete the Final Drawing**

*Complete a detailed drawing of the wyvern, paying particular attention to the texture of the wings and hide.*

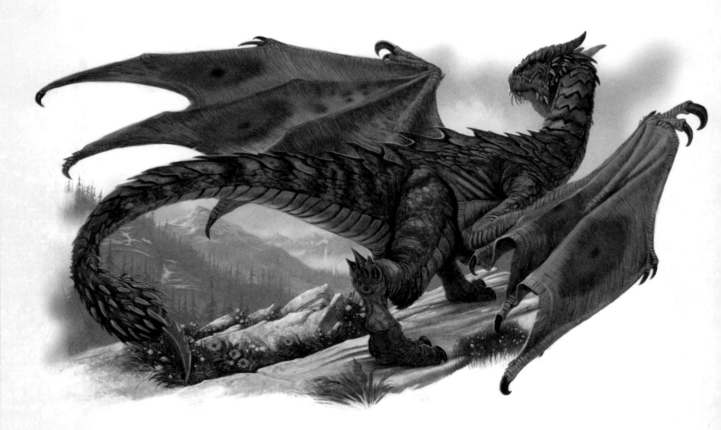

*Continue sketching your ideas, then complete a final drawing on another sheet of paper, giving your dragon color if you like.*

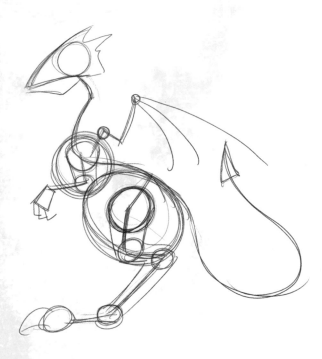

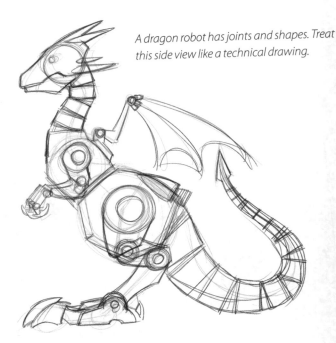

*A dragon robot has joints and shapes. Treat this side view like a technical drawing.*

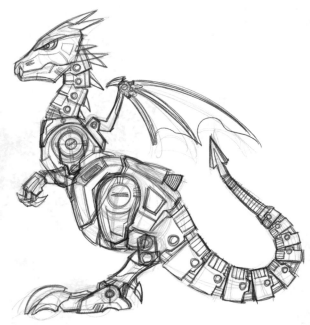

## 1 Create the Skeletal Structure
*Use the joints and limbs to work out a structure that is pleasing. Notice that the leg is jointed twice. The dragonlike features should already be apparent.*

## 2 Add Basic Shapes
*A dragon robot moves differently than a humanoid robot, so make sure that the joints and shapes interact correctly. Draw the tail and neck as a series of shapes that can move. The leg needs different shapes than a humanoid too. The foot claw is separated into segments. The head is angular.*

## 3 Draw Rough Details
*Add detail and refine your rough shapes. Use similar shapes for the neck and tail to show that they move similarly. Use similar shapes for the claws of the hands and feet since they serve a similar purpose. Explore the details of the joints at the hip and shoulder. Examine the curvature of the mouth.*

## FEATURES OF A DRAGON

*Toy with this drawing until you have a creature with dragonlike proportions: large, lizardlike head; long neck and tail; smaller wings and forearms and clawed hands and feet.*

*Paying close attention to joints and limbs, do some sketches to work out your shapes.*

# DRAGON ROBOT: SIDE VIEW

**4 Finish Details and Ink**
*Outline the larger body shapes with thick ink lines. Use thinner lines for the small body parts and details. Shadows in small sections of the body give the appearance of mechanical holes or nooks. A robot is made from parts; give each part its individual flavor to make the whole robot realistic.*

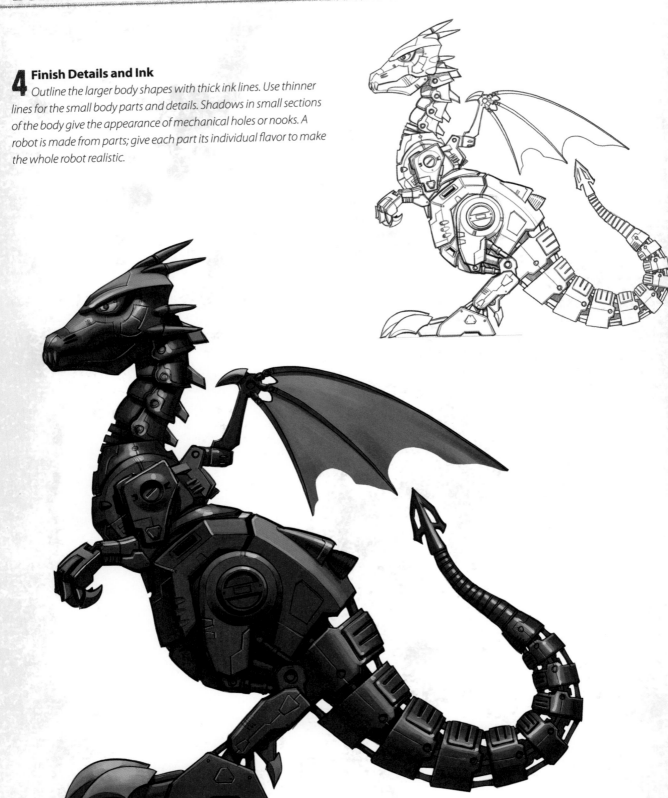

*Once you know how you want your shapes, try sketching them with ink. Finish your more detailed drawing on a separate piece of paper. Add color if you like.*

# DRAGON ROBOT: THREE-QUARTER VIEW

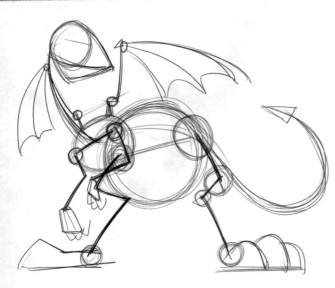

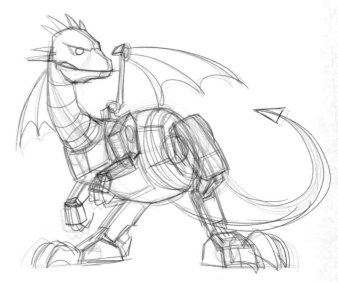

**1 Create Skeletal Structure**
Draw the skeletal structure in this view. The angles of the arms, legs, chest and hips are all different. Draw the center body mass and joints as general circles. Make sure they work together with the limbs to make the pose look fluid. The head facing back toward the body balances the figure.

**2 Add Basic Shapes**
Take your time in this step. Draw the basic shapes from the skeletal structure. Rough in the fingers, feet, mouth, wings and eyes. Every shape will be different. Work carefully on the joints and angle of the facing leg. Remember the motion of a joint as you draw the shapes connected to it.

**3 Draw Rough Details**
Add details by further refining the basic shapes and adding mechanical elements to the surfaces. Decide where your major shapes will be. Notice here how the roundness of the outside hip is now an angled mechanical piece. Explore the joints of the wings and legs. There is ample room for movement in the lower leg here as its casing recedes from both the knee and ankle.

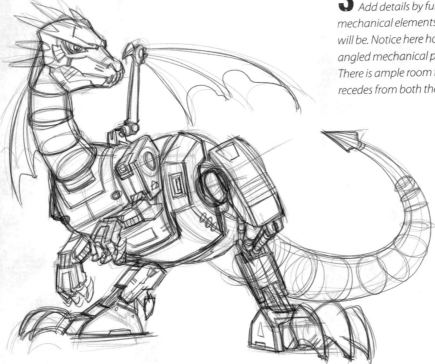

*Sketch basic shapes and rough details here.*

# DRAGON ROBOT: THREE-QUARTER VIEW

**4 Finish Details and Ink**
*Outline the shapes and details. Create shadows by means of complete black or by crosshatching to achieve a gray. The shadows under each neck piece emphasize that the neck is indeed a series of individual pieces.*

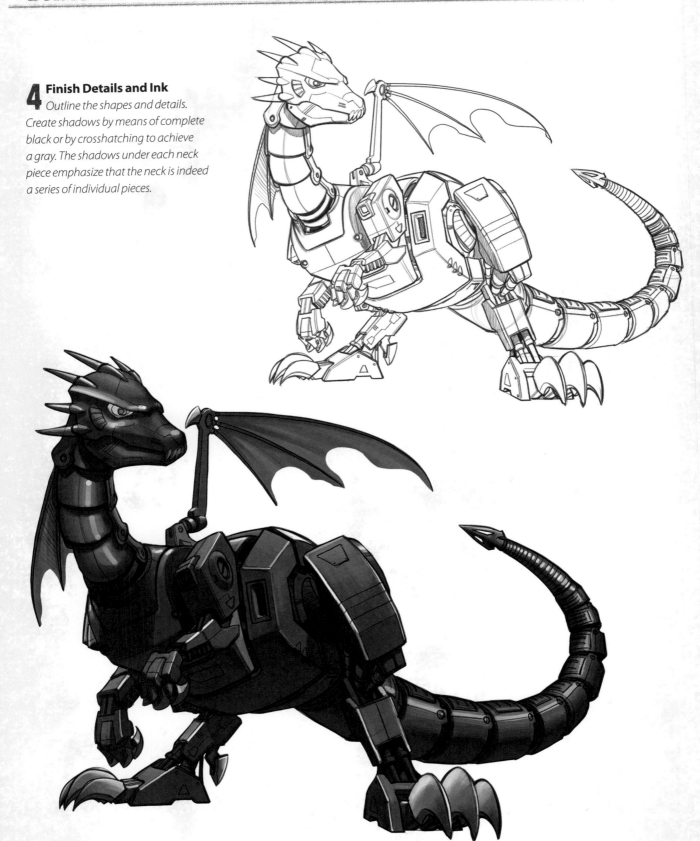

*Continue to sketch shapes, details and shadows. Complete your final drawing on a separate sheet, adding color if you like.*

# DRAGON ROBOT: BATTLE POSE

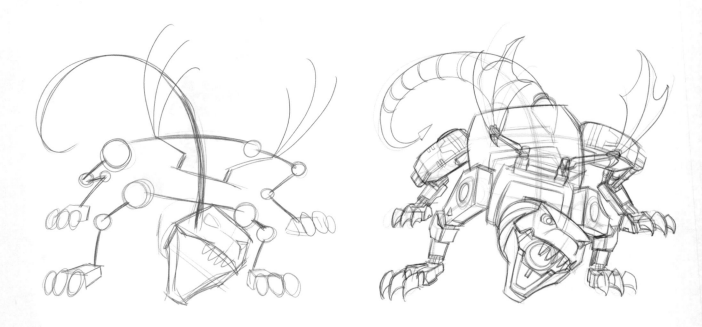

**1 Create Skeletal Structure**
Pay special attention to the angle of the hind legs. Draw the hindquarters so that they are visible. The head is down and poised for battle. Rough in the angle and shape of the head.

**2 Add Shapes and Rough Details**
Build the shapes of the body from the skeletal structure. Keep the limbs separated by visible joints. When the joints aren't visible, keep a distance between adjoining forms, such as the hind legs and hip. Notice how the shape behind the head—the torso—is tilted with the head and the bending of the robot's front left leg.

**3 Finish Details and Ink**
Ink the major shapes that have outside edges with thick lines. Use thin lines for interior edges, details and shapes farther in the background.

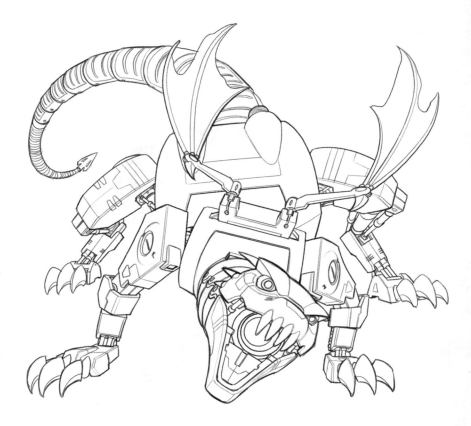

*Sketch your major shapes and details.*

# DRAGON ROBOT: BATTLE POSE

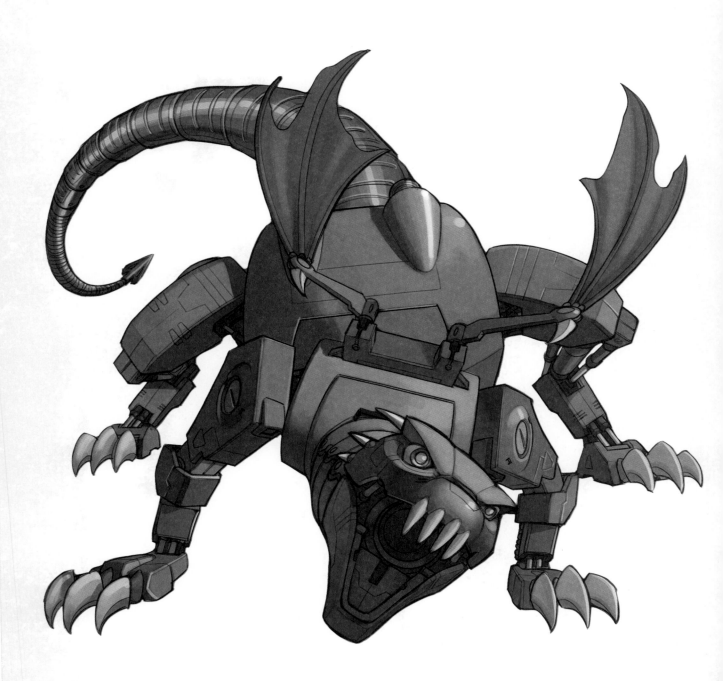

 Learn more about dragons at http://ImpactSketchbooks.Impact-Books.com

*Sketch your final pose, then do a more finished drawing on another sheet of paper, adding color if you like.*

**Sketch Dragons: A Draw-Inside Step-by-Step Sketchbook.** Copyright © 2011 by IMPACT Books. Manufactured in China. All rights reserved. No part of this book may be reproduced in any form or by any electronic or mechanical means including information storage and retrieval systems without permission in writing from the publisher, except by a reviewer who may quote brief passages in a review. Published by IMPACT Books, an imprint of F+W Media, Inc., 4700 East Galbraith Road, Cincinnati, Ohio, 45236. (800) 289-0963. First Edition.

 Other fine IMPACT Books are available from your favorite bookstore, art supply store or online supplier. Visit our website at www.fwmedia.com.

15  14  13  12  11    5  4  3  2  1

DISTRIBUTED IN CANADA BY FRASER DIRECT
100 Armstrong Avenue
Georgetown, ON, Canada  L7G 5S4
Tel:  (905) 877-4411

DISTRIBUTED IN THE U.K. AND EUROPE BY
F&W MEDIA INTERNATIONAL, LTD
Brunel House, Forde Close, Newton Abbot, TQ12 4PU, UK
Tel: (+44) 1626 323200, Fax: (+44) 1626 323319
Email:  enquiries@fwmedia.com

DISTRIBUTED IN AUSTRALIA BY CAPRICORN LINK
P.O. Box 704, S. Windsor NSW, 2756 Australia
Tel:  (02) 4577-3555

Edited by Pamela Wissman and Kathy Kipp
Cover designed by Laura Spencer
Interior designed by Wendy Dunning
Production coordinated by Mark Griffin

Special thanks to the following artists whose work appears in this book:
William O'Connor
Stephanie Pui-Mun Law
E.J. Su
Tom Kidd
Chuck Lukacs

The artwork in this book originally appeared in previously published IMPACT and North Light Books. Page numbers shown below refer to the pages in the original books.

*Dracopedia* © 2009 by William O'Connor.
Pages 10-11, 14-15, 68-69, 84, 85, 89, 142, 143, 145, 154, 155, 157.

*Sketchbook Confidential* © 2010 by North Light Books. Edited by Pamela Wissman and Stefanie Laufersweiler.
Page 107, artwork by William O'Connor.

*Dreamscapes Myth & Magic* © 2010 by Stephanie Pui-Mun Law.
Pages 130, 131, 132, 133, 134, 135.

*OtherWorlds* © 2010 by Tom Kidd.
Pages 27-28, 29, 82, 83, 84, 189.

*Wreaking Havoc* © 2008 by Jim Pavelec, Chuck Lukacs, Thomas Manning, Christopher Seaman.
Pages 85, 86 artwork by Chuck Lukacs.

*MechaForce* © 2008 by E.J. Su.
Pages 92, 93, 94-95, 100, 101.

## METRIC CONVERSION CHART

| To convert | to | multiply by |
| --- | --- | --- |
| Inches | Centimeters | 2.54 |
| Centimeters | Inches | 0.4 |
| Feet | Centimeters | 30.5 |
| Centimeters | Feet | 0.03 |
| Yards | Meters | 0.9 |
| Meters | Yards | 1.1 |

# IDEAS. INSTRUCTION. INSPIRATION.

*Dracopedia • hardcover • 160 pages*

*Dreamscapes Myth & Magic • paperback • 176 pages*

*Sketchbook Confidential • paperback • 176 pages*

*OtherWorlds • hardcover • 192 pages*

*Wreaking Havoc • paperback • 128 pages*

*MechaForce • paperback • 112 pages*

## IMPACT-BOOKS.COM

- Connect with other artists
- Get the latest in comic, fantasy, and sci-fi art
- Special deals on your favorite artists